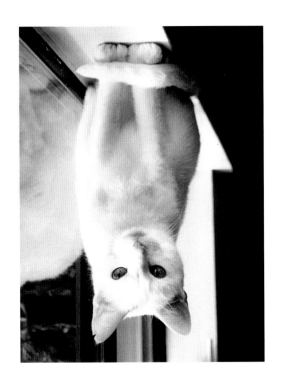

FOR BEV AND SHIRL, THE MOST FABULOUS GALS WE KNOW.

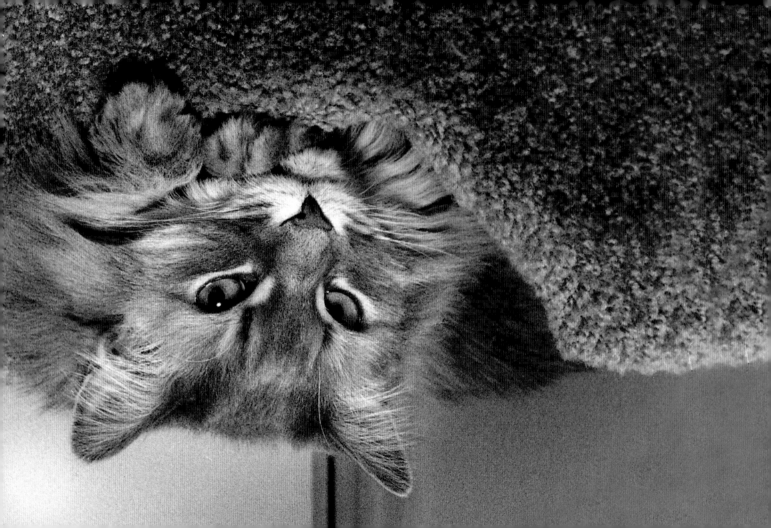

cat**TITUDE**

THE FELINE GUIDE TO BEING FABULOUS

Photographs by KIM LEVIN

Written by CHRISTINE MONTAQUILA

STEWART, TABORI & CHANG • NEW YORK

Published in 2005 by
Stewart, Tabori & Chang
An imprint of Harry N. Abrams, Inc.

Edited by Marisa Bulzone and Dervla Kelly
Graphic Production by Alexis Mentor
Designed by Susi Oberhelman

ISBN-13: 978-1-58479-691-6
ISBN-10: 1-58479-691-X

The text of this book was composed in Futura and Berthold Bodoni.

Printed and bound in China by Midas Printing Ltd.

10 9 8 7 6 5 4 3 2 1

HNA
harry n. abrams, inc.
a subsidiary of La Martinière Groupe
115 West 18th Street
New York, NY 10011
www.hnabooks.com

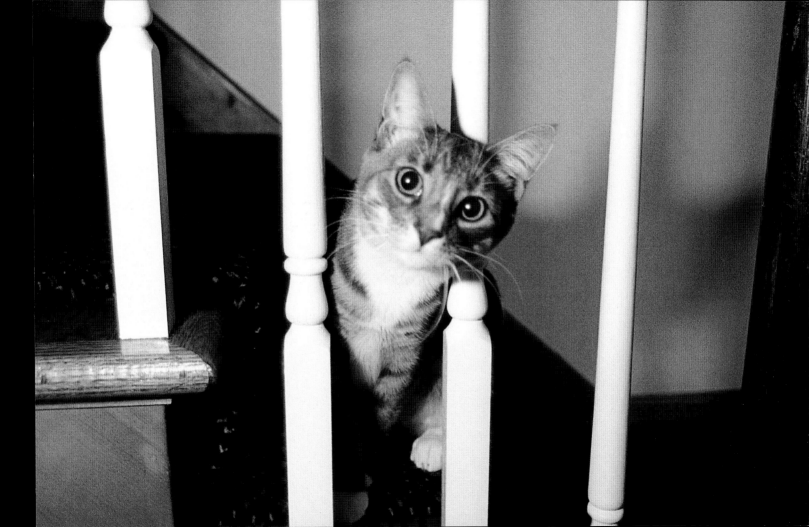

Realize a tiara is a state of mind.

HARRY

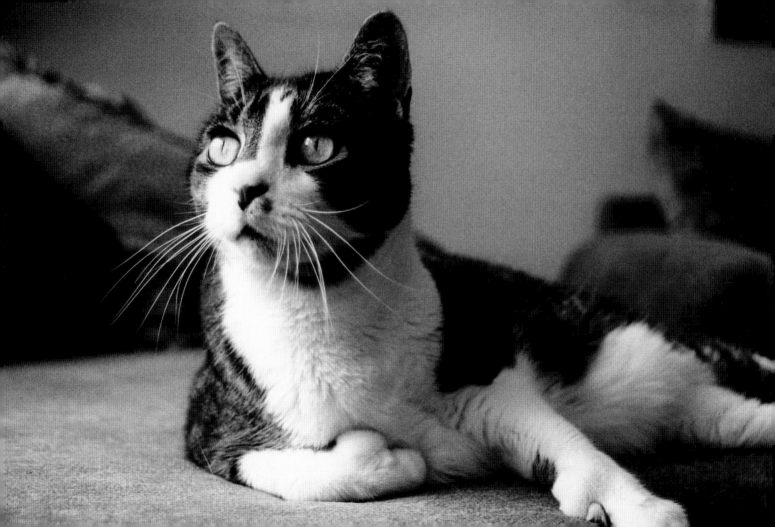

Obsess hourly over your hair.

PICKLE

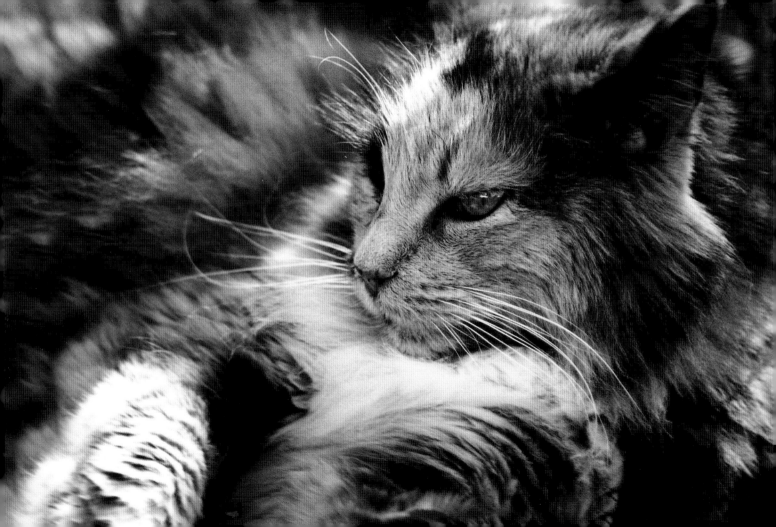

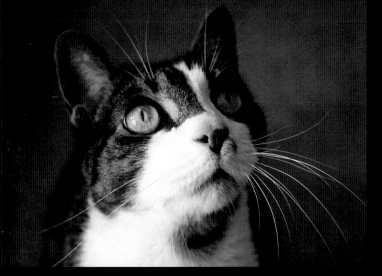 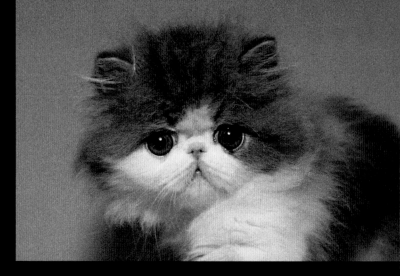

Have a stash of who-me looks in your repertoire.

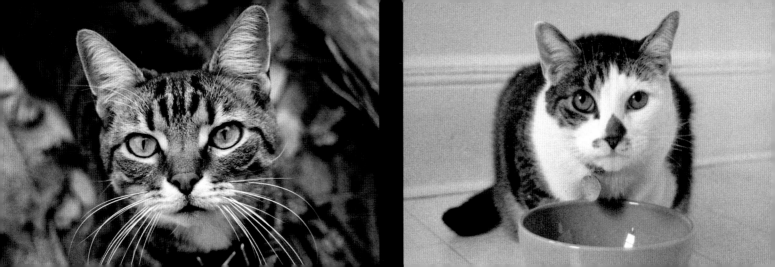

Don't be afraid to **show** a little **leg**.

ZOE

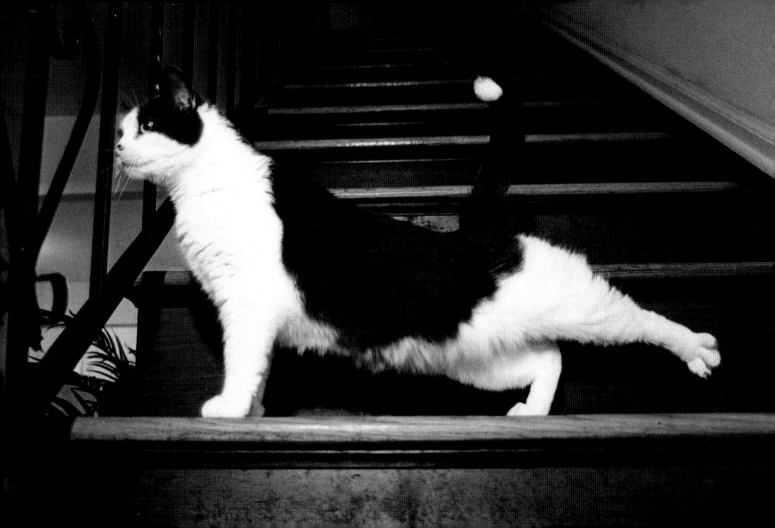

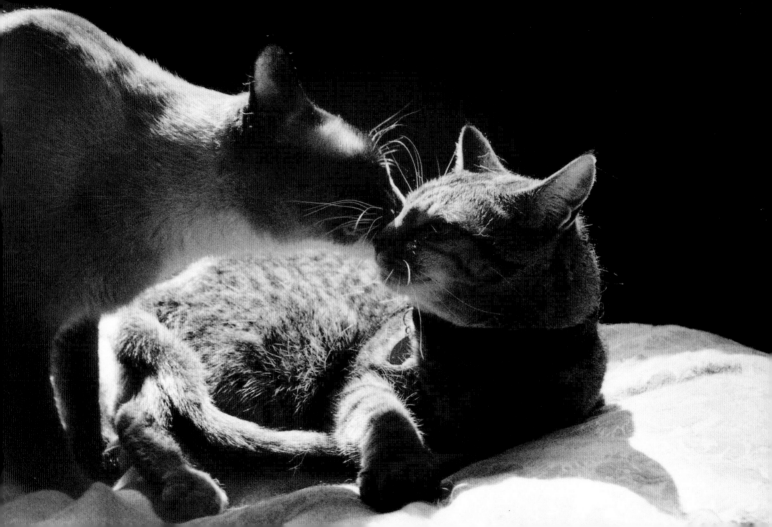

Hang out exclusively with

people who adore you.

HANNAH AND ALVY

If you're **blessed** with a little extra, **flaunt it.**

HARRY

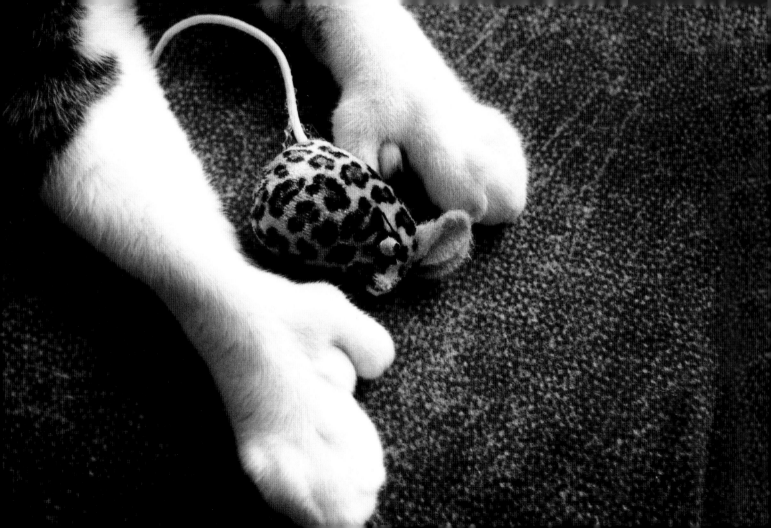

Worship the sun.
But act like it's worshipping you.

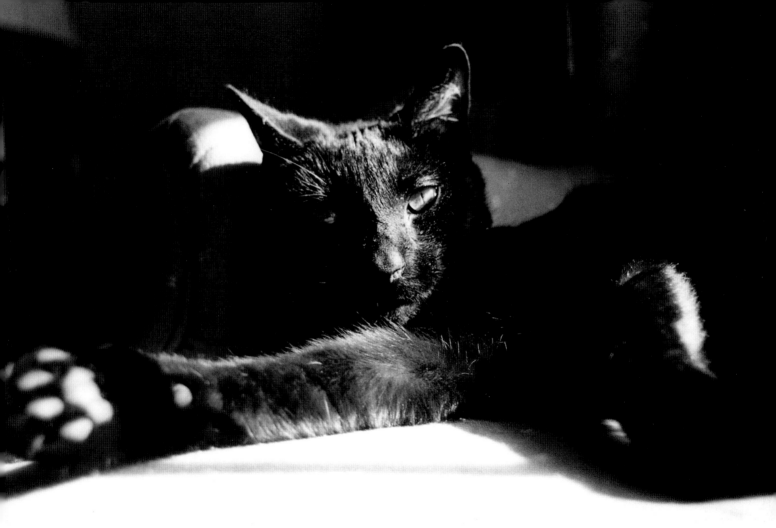

Tap into your inner bad-ass.

ZOE

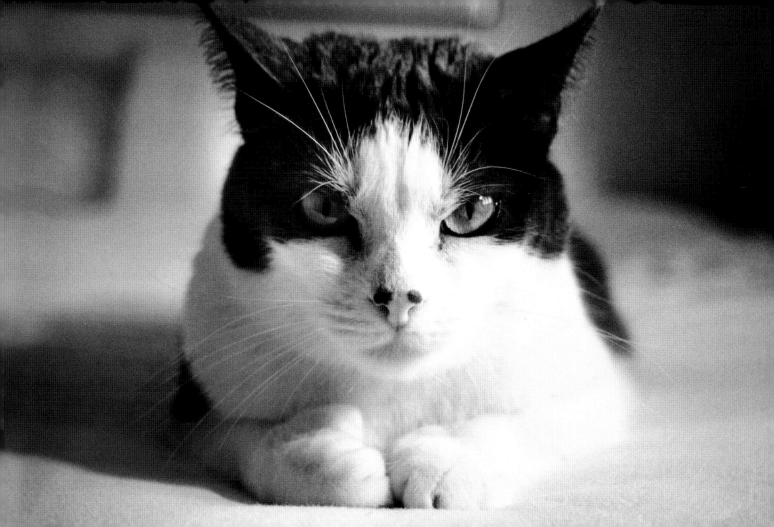

If you can't be the **prom queen**,
be the **drama queen**.

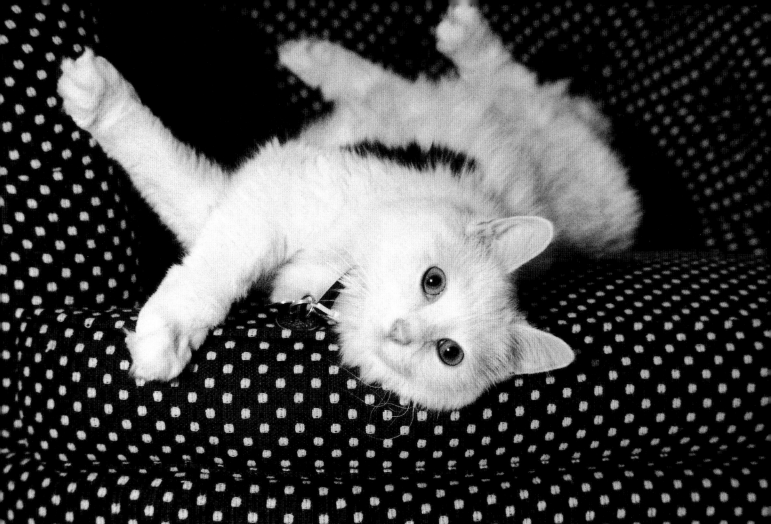

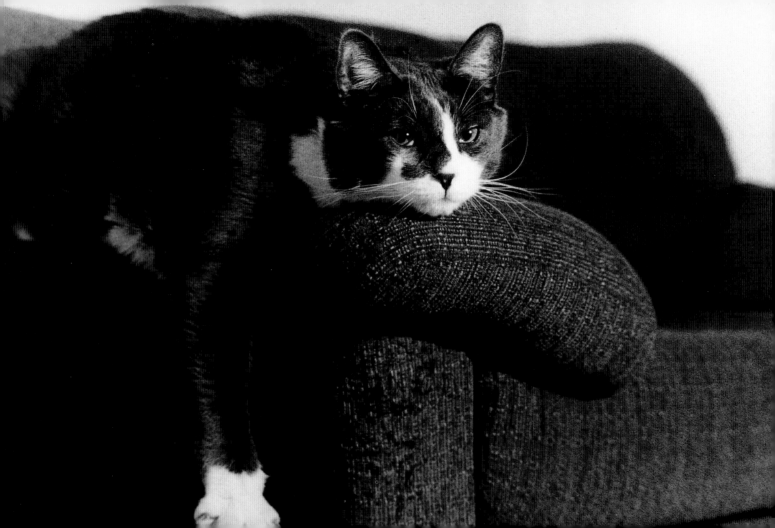

Unless you **made** the rules, **ignore** them.

Keep your expectations and
your thread counts high.

ISABELLE

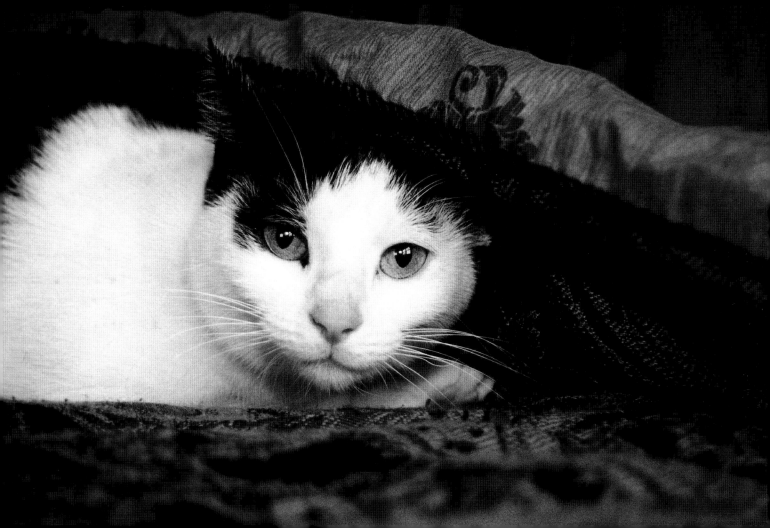

Make immediate gratification your mantra.

EMILY

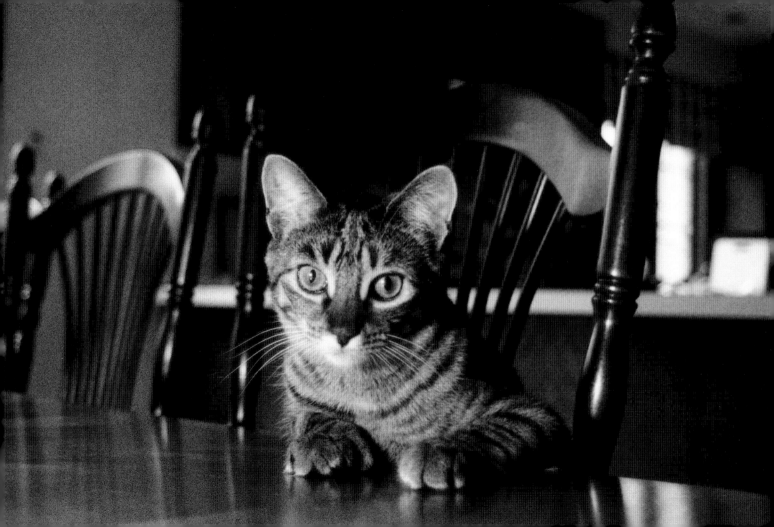

Remember confrontational
girls finish first.

ANNA

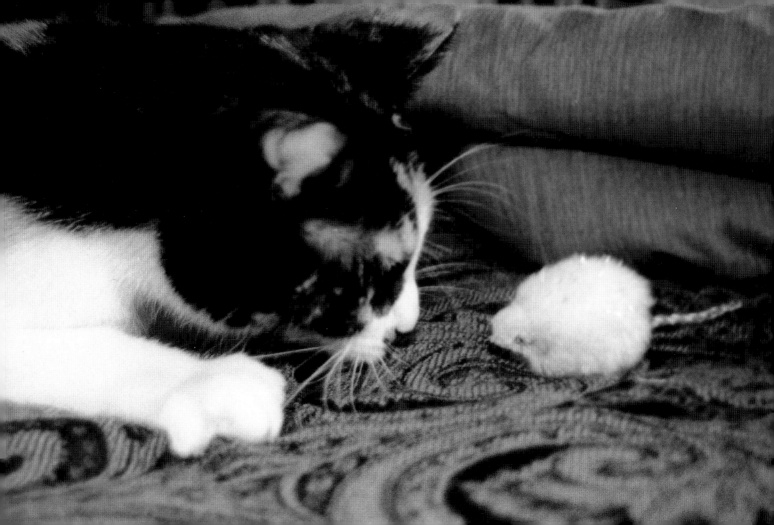

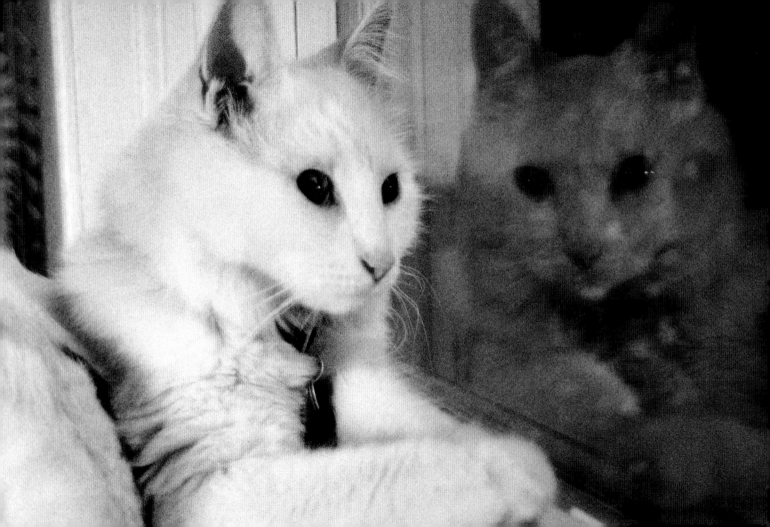

Clean windows only to improve your reflection.

Institute a girls' night out rule.

HAZEL, ELOISE, AND SEYMORE

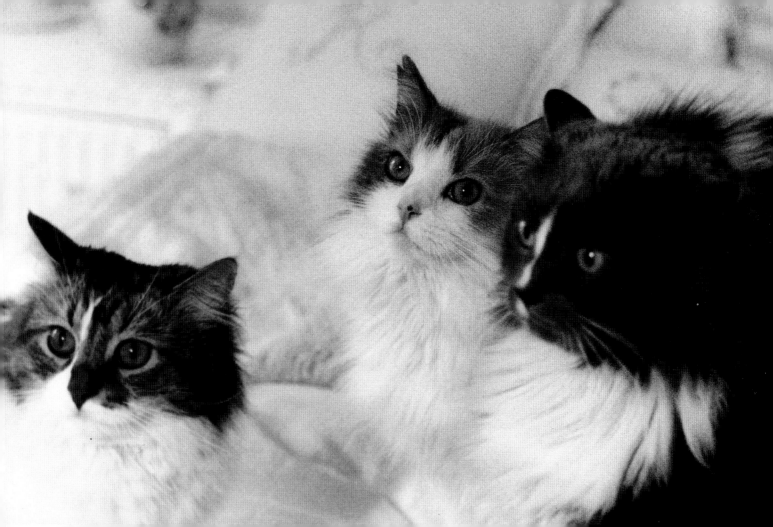

Learn to love the paparazzi.

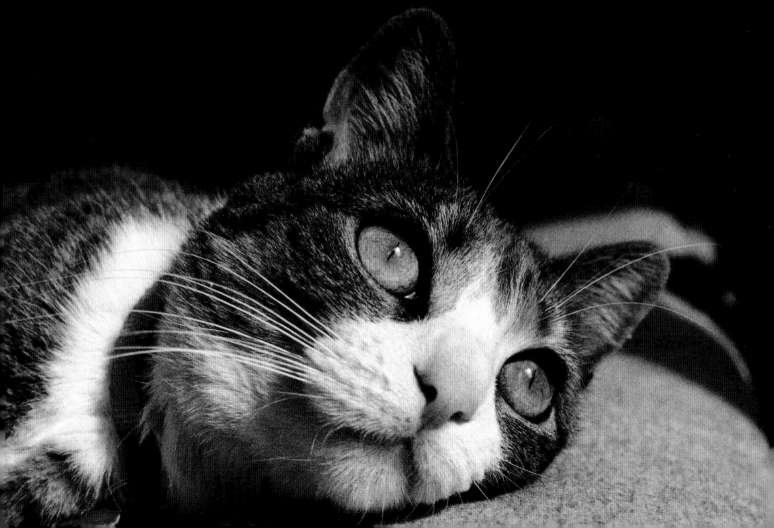

Remember good lighting is
more important than good genes.

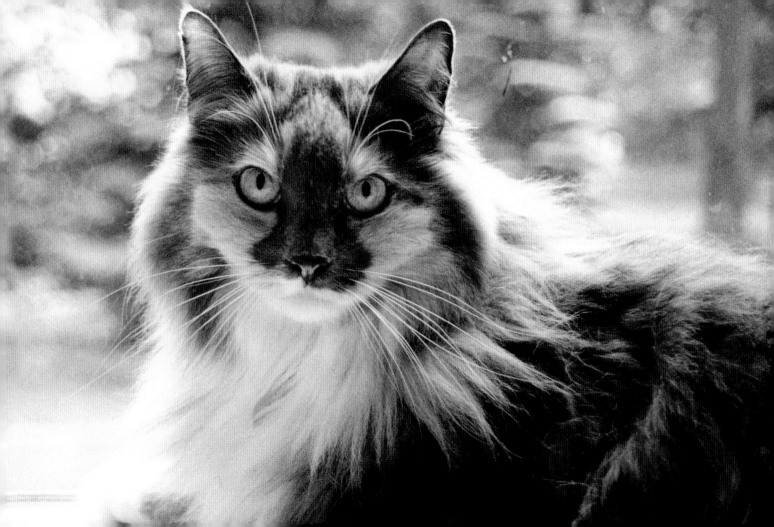

Know the only dog worth your time
is downward facing.

ZOE

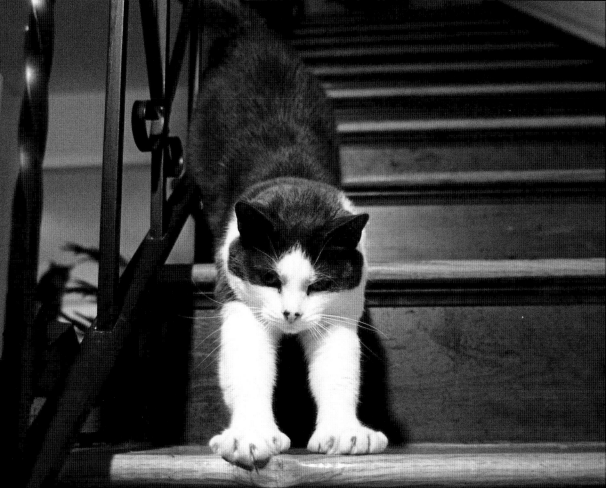

Have friends that raise a few eyebrows.

OWEN

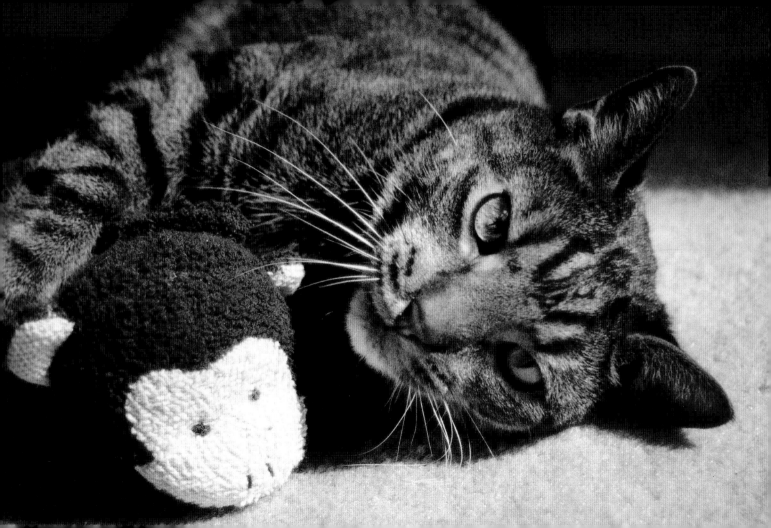

Claim the bathroom as your turf.

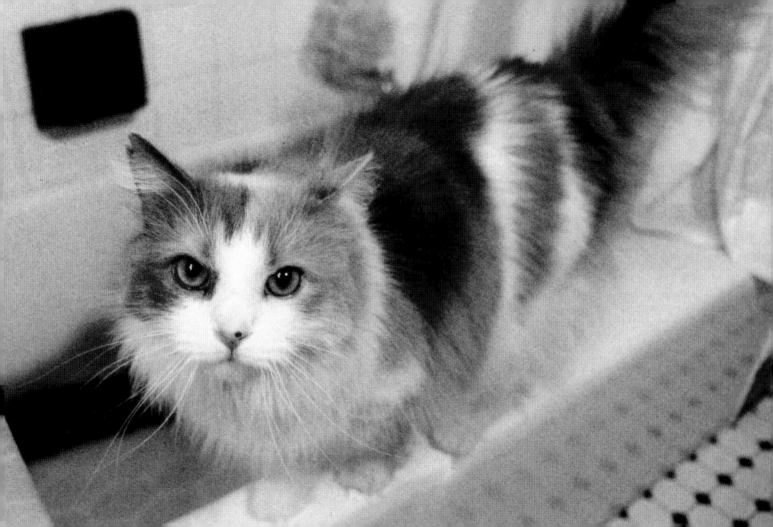

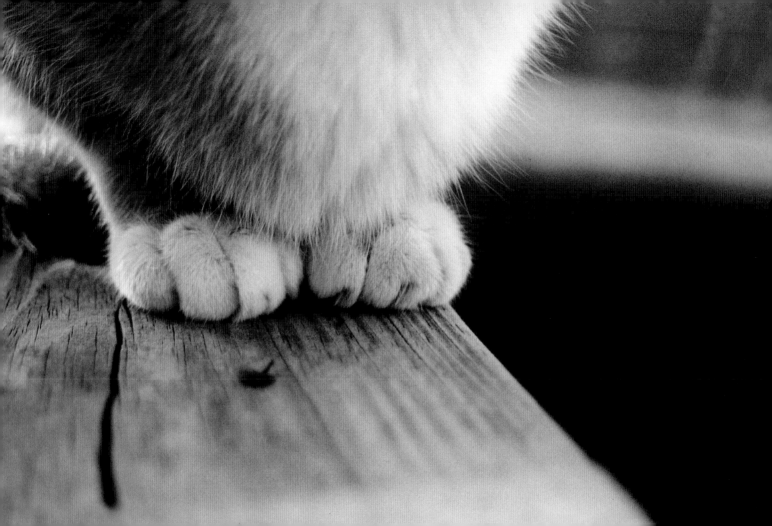

Know your manicurist like family.

MAUDE

Accept your **body**. Augment your **ego**.

BING

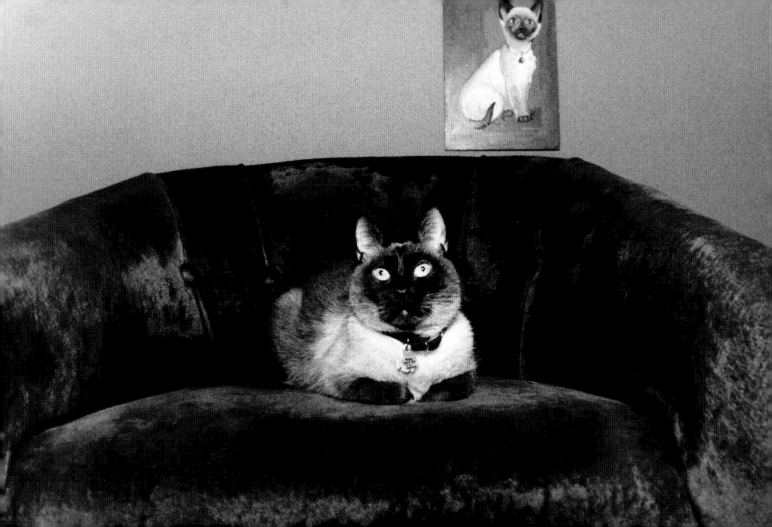

Get yourself an entourage.

MOUSE, MIDGE, AND HARRY

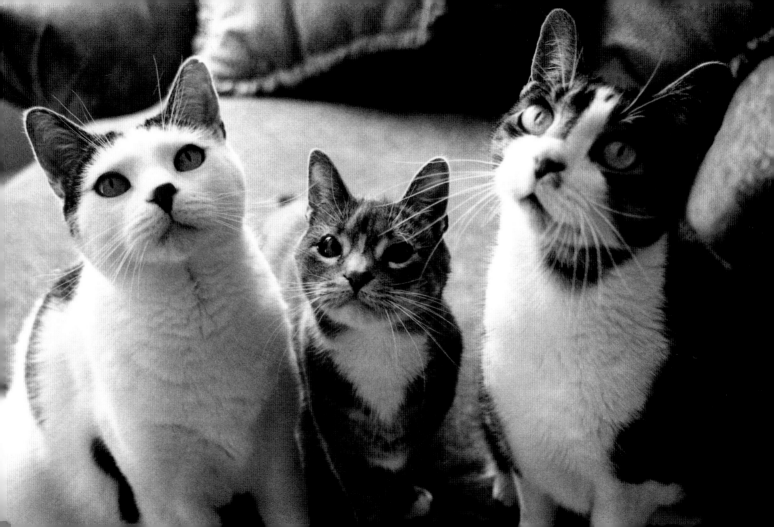

Don't whisper when you can roar.

CHLOE ROYALE

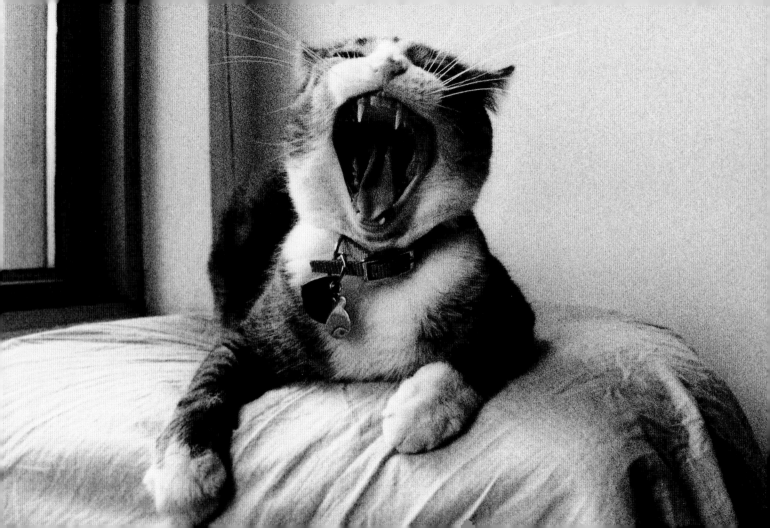

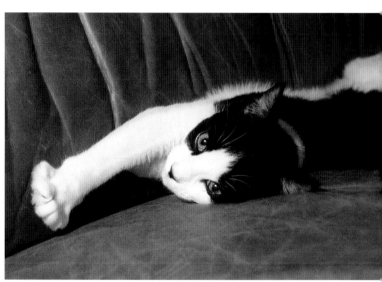

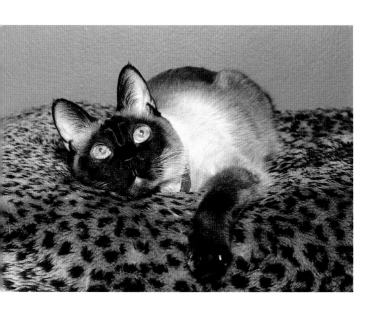

Have one good
come-hither look.

SPYDER, ENZO, AND BING

Embrace your irrational love of shoes.

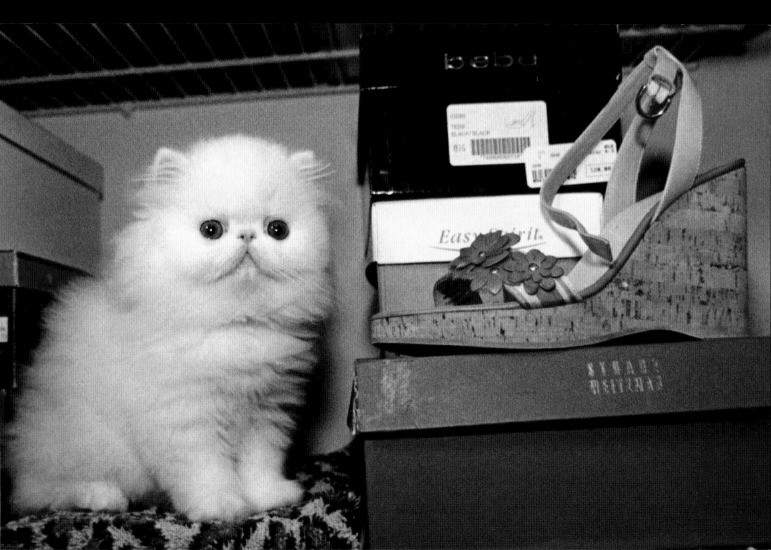

When life gets tough, get zen.

LIZZIE B.

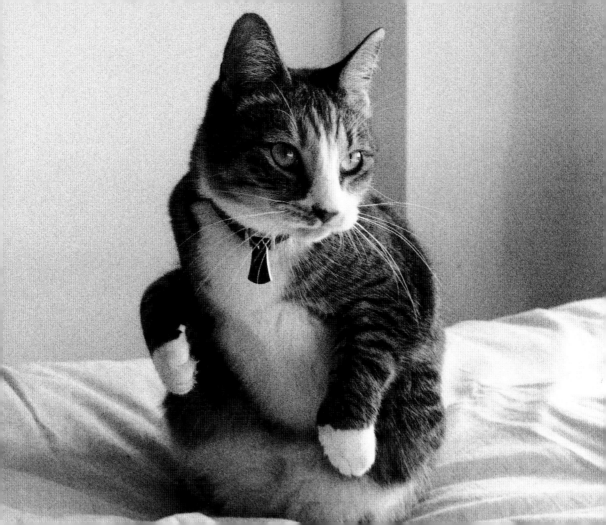

Understand a pretty face isn't a gift, it's a tool.

MOUSE

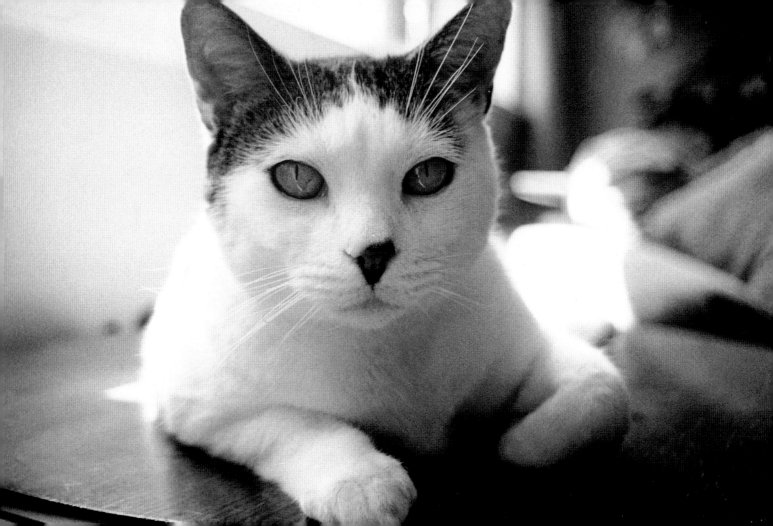

ACKNOWLEDGMENTS

Thanks to Marisa Bulzone and STC for saying yes. Thanks to Jim Hutchison for his printing prowess. Thanks to John, Ian, Brad, and Luca, the fabulous men in our lives, and to Frankie Rose, our newest diva in diapers. And to the pets who rule our lives, Cosmo, Maddie, and Charlie, for all your high maintenance, prima donna-like inspiration.

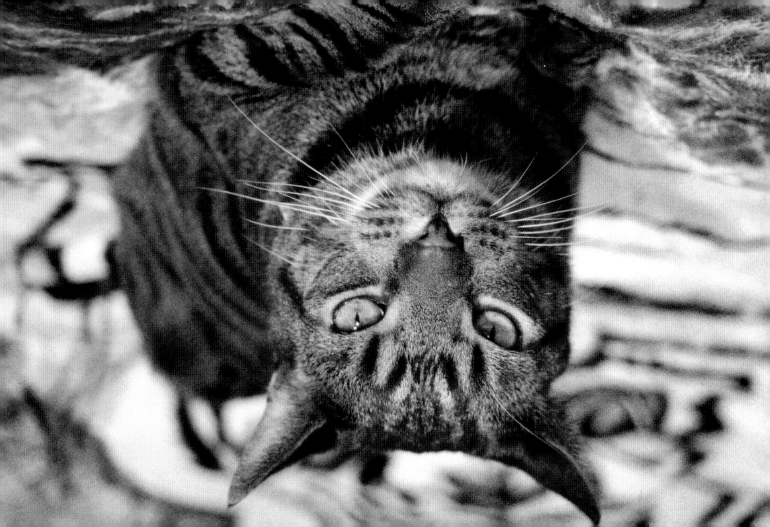

ABOUT THE AUTHORS

By day, CHRISTINE MONTAQUILA works in advertising as a creative director. She lives in Chicago with her husband Brad, son Luca, daughter Francesca, and their two tiger kitties, Cosmo and Maddie. She has loved cats since childhood and has the scars to prove it.

KIM LEVIN is a photographer who specializes in pet portraiture. Her company, Bark & Smile® Pet Portraits, combines her passion for photography and her love of animals. Kim has published ten books including *Why We Love Dogs*, *Why We Love Cats*, *Growing Up*, *Dogma*, *Working Dogs: Tales from Animal Planet's K-9 to 5 World*, and *Erin Go Bark!* Her books have sold a quarter million copies and have been published in six languages.

A passionate advocate of animal adoption, Kim has been donating her photography services and supported The ASPCA, Petfinder.com, and her local shelters for many years. Kim lives in Little Silver, New Jersey, with her husband John, son Ian, daughter Rachael, and Charlie, their adopted border collie/greyhound mix.

Kim and Christine have been partners in crime since the 7th grade.